T0197569

Ekphrasis Definition

Etymology: Greek *ekphrasis*; literally, description; from ekphrazein, to recount, describe; from ex- out + phrazein to point out, explain; a literary description of or commentary on a visual work of art. *

A rhetorical device, in which one medium of art relates to another medium by describing its essence and form, and in doing so, connects more directly to the audience.

A descriptive work of prose or poetry may thus highlight what is shown in any of the visual arts, enhancing the original art and taking on a life of its own through its description. Virtually any type of artistic media may be the actor of, or subject of ekphrasis. In this way, a poem may represent a painting, or vice versa. **

In this work:

* Merriam-Webster online dictionary
** Wikipedia

Whatever you can do or think you can begin it. Boldness has genius power and magic in it. — Goethe

Table of Contents

Introduction

David McCauley doodled in school and was influenced by the works and lives of Vincent Van Gogh and Salvadore Dali.

In his mid-twenties he dabbled with how-to-paint books while drawing on sketch pads and painting on small canvas boards. Marriage and family took precedence over art from 1970 to 1998. After matting & framing and beginning watercolor classes with Joan Dougherty at the Pleasant Hill Recreation & Parks District (PHRPD), he took evening classes in impressionist oil painting with George Holmes at Mt. Diablo Adult Education (MDAE) in Pleasant Hill, CA. Retirement in 2001 allowed more time for drawing, watercolor, acrylic, and oil classes at MDAE and Walnut Creek Recreation Center. Plein Air painting in Mt Diablo State Park with his friend Ron Jennings (who graduated from San Diego State University with Art/English majors) taught him more about watercolor. They learned wet-on-wet technique at a weekend workshop in the studio of Monte Guynes in Fresno. In 2002 Trudi Edwards taught him more about oil & watercolor painting through PHRPD. David thanks Joan, George, Ron, and Trudi for their help.

His Artist Statement reads, "As far back as I can remember I have been enchanted by the beauty of nature around us . . . majestic mountains, wild coastland, colorful skies, and mystic forests. This beauty is especially moving to me when the sun is low, and its light is filtered through dust and clouds to form spectacular, vibrant scenes."

Since 2002, under the guidance of Elaine Starkman at MDAE, David learned to write memoirs and (since 2006) poetry. She encouraged him to pursue his idea of combining the two art forms . . . painting and poetry. Ekphrasis includes both poems about his paintings and sketches about his poems.

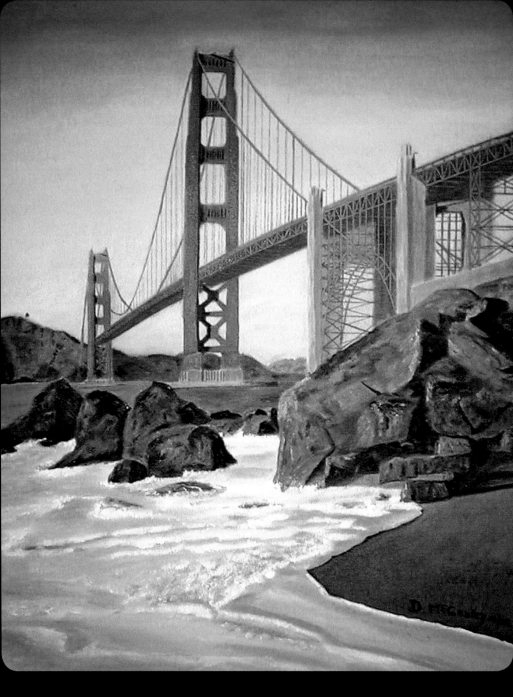

Bridge

Spanner of the blue inlet
Ghostly sails glide beneath your lofty deck

As fireball sets, your towers glow
with flaming hue of crimson sky

Moist air engulfs you
Your cables breathe Pacific fog

Traffic lights line your path
Snakes of red and white slip through the dark

From churning water to sighing stars
Night is lifted in your arms *

* After Hart Crane

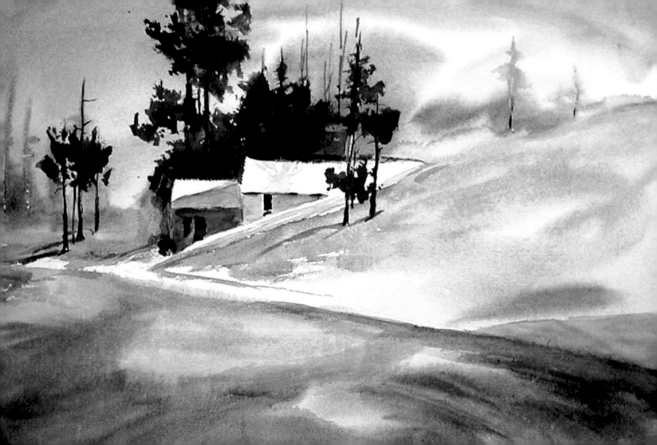

Cabin

Stormy grey sky reflects low afternoon sun

Distant trees soften to green broomsticks

Cold fog rolls in from distant ridge

Cabin stands waiting with fresh snow

Sun shines through to radiant roof

Haven of warm comfort

In mountain solitude

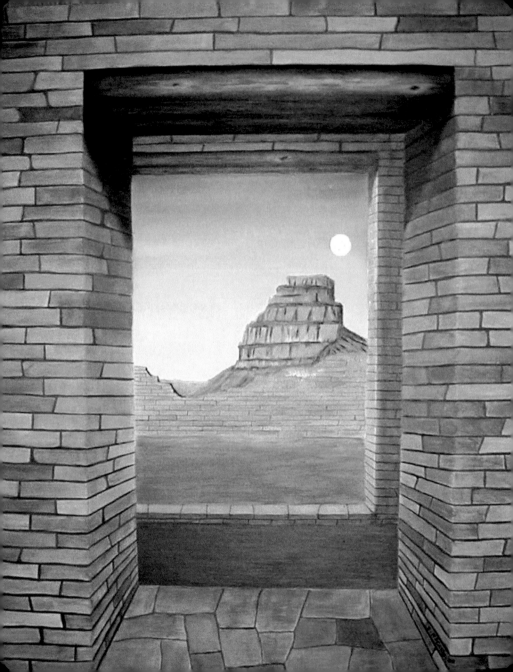

Chaco Moon

Oh Anasazi, why did you come to Chaco Canyon

Was it abundance of orange sandstone
glowing bright in the evening sun
while full moon rises in sky of blue

Was it fertile soil and flowing water
growing beans, maize, squash and chilies
from land that must feed you

Were you drawn like a moth to Fajada Butte,
red rock monolith rising from the valley floor
drawing your gaze, day and night

Why build pueblos for four centuries
with layer upon layer of stone slabs
and doors that open to far views

Why did you align walls and roads
to limits of sun and moon

I walk through time,
from new stone rooms
to Kiva courtyards with crumbling walls

Oh Anasazi, why did you leave your Chaco home
Where are you now, and why did you roam

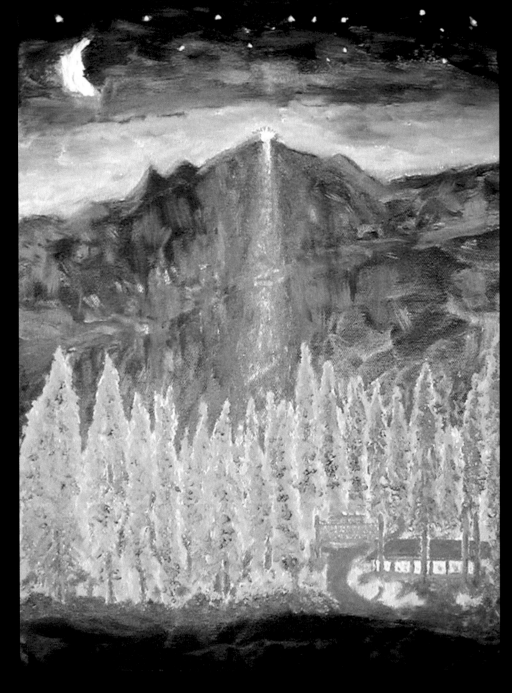

Firefall

Afternoon bonfire burns
five feet from the Glacier Point precipice

Thunderclouds rumble across the sky
ready to be painted by the setting sun
Light fades fast to pink, purple, and blue

David Curry calls up from Yosemite Valley floor
LET THE FIRE FALL

Fire tenders shove thick piles of hot coals
over the cliff
with a long metal pushers

What a view from the meadow below
Red and orange embers
cascade down to the bottom
mixing with granite scree

Thousands watch in silent awe
captivated by the light of fire on rock
behind green trees of Camp Curry

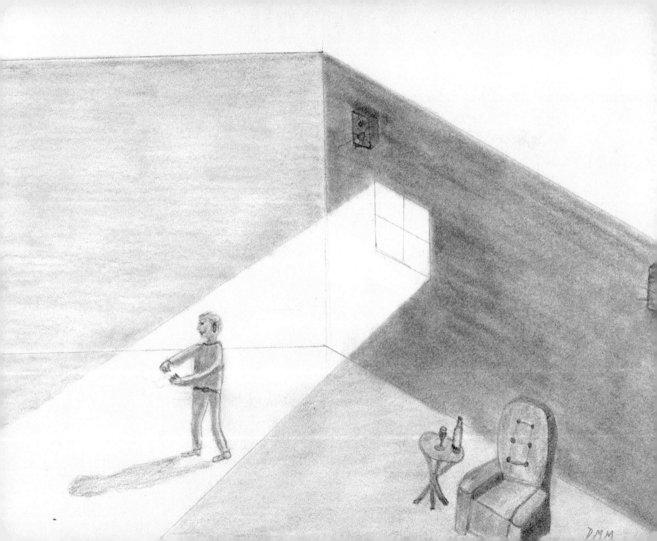

Moon Dance

Alone again
Raising my burgundy glass to the sparkling window pane
I invite Miss Moon to join me and my Shadow

I begin a chorus of Shine On Harvest Moon
My two guests prefer silence
I empty another glass,
stand, and begin to dance
in the moonlight

I embrace my grey partner delicately
She's just inches away
on the wall
As we turn,
the Blue Danube
guides us around the room in 3/4 time

My gliding legs stagger
The waltz wanes
I bow to my partner,
seeking solitude in my big soft chair

Sliding into sullen slumber
I bid goodnight
to Moon and Shadow,
vowing to see them soon
in my dreams

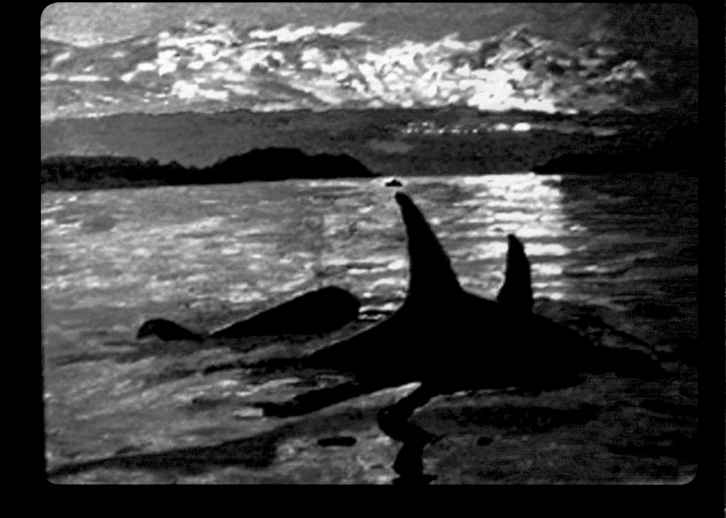

Orcas

Two frolicking Orcas
engage a nearby pilot whale
coursing waters of Puget Sound

Their graceful gliding at gas/liquid border
echoes elegance of eagle's soar
Poetry of motion

A fiery sunset plays orange and purple
on peaks and troughs of waves,
stirred by prevailing west wind
and swimming mammals

One dorsal fin points to distant boat
The second points to setting sun

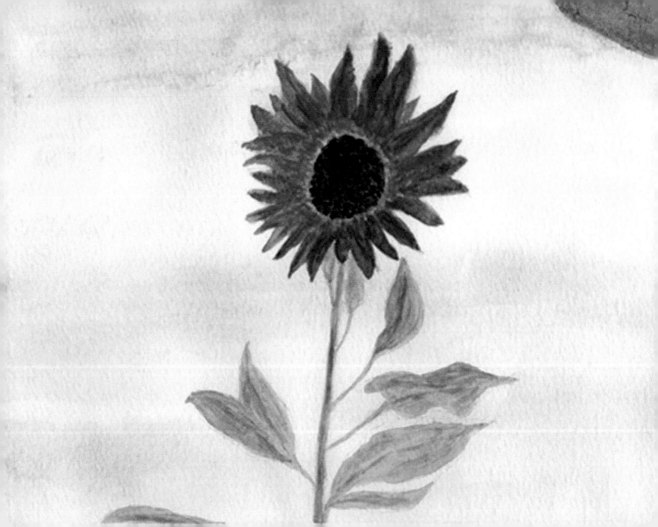

Seeds

Sow a seed on fertile ground

Add water wait

Seed softens, stirs inside, awakens
Sprout pokes its green head through dirt

Add water wait

Sun rays splash on the young shoot
It stiffens and rises
Leaves leap out sucking in more sun

Add water wait

Plants grow and blossom,
as smiles grow into love

Flowers become fruit,
bursting with flavor and myriad of seeds

Fruit may be eaten
Seeds may be sown

Add water wait

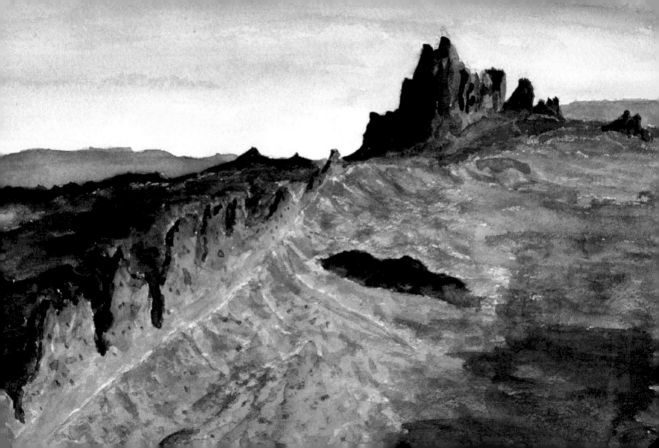

Volcanic Remnants

Hard igneous rock
born of fire below
oozed into cracks in the ground
forming long walls,
pointing at the brown monolith
standing tall in the distance

Low sunlight turns brown rock to lava hue,
mimicking its birthing color of eons before
Volcanic core remnants
left by soil eroding away

Named Shiprock after a clipper ship
sailing across the New Mexico plain,
enticing travelers to seek closer view

Navajo call it Tse Bit'a'i...sacred winged rock
Two peaks are tips of raised wings
of the great bird that brought them
from the north to their present land

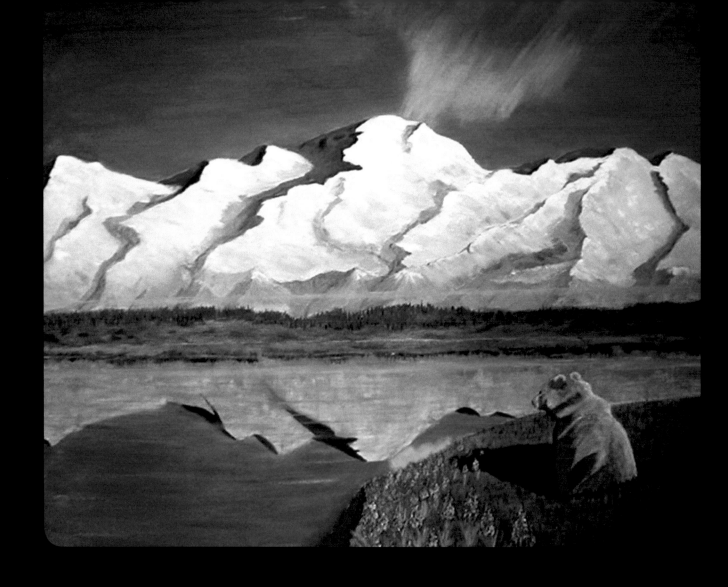

Watching Mckinley

Brown grizzly bear sits and stares
at this pleasing midnight scene

Fireweed glows at his feet,
like hot coals of evening fire

Thin cloud hovers above green trees
Moist breath from lake below

Highest mountain on Turtle Island
pulls his gaze to lofty peak

Flood of light from nearest star
bathes bright snow with orange streak

Sun flares excite atoms to
shimmering shades of green, red, blue

Wonder Lake reflects this view
of summer color that Nature drew

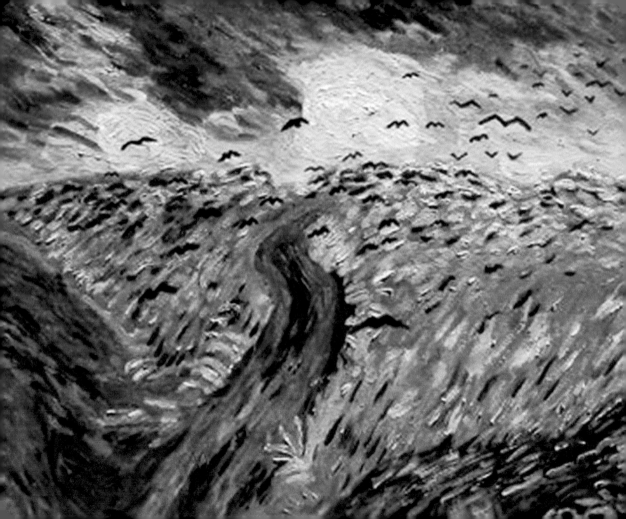

Wheatfields

Dark blue thunderclouds
with patches of white
Dark depression,
Theo has family now

Wheat shafts wave
in a violent wind
Who will feed Vincent now
Where can I go

Green grass grows
but on a dead end road
Pastures a plenty
but my art won't sell

Where do you fly
black crow flock
Where will you take me
smooth black gun

The painting to the left is a copy of Van Gogh's Wheatfields With Crows,
painted by David McCauley.

To order additional copies of this book, contact:
Xlibris
844-714-8691
www.Xlibris.com
Orders@Xlibris.com

ISBN: Softcover 978-1-4535-5887-4
 EBook 978-1-6698-5233-9

Print information available on the last page

Rev. date: 10/20/2022

Printed in the United States
by Baker & Taylor Publisher Services